WORD PROBLEMS

PROBLEMS WORD

WORD PROBLEMS

POEMS

IAN WILLIAMS

COACH HOUSE BOOKS, TORONTO

first edition

Published with the generous assistance of the Canada Council for the Arts and the Ontario Arts Council. Coach House Books also acknowledges the support of the Government of Canada through the Canada Book Fund and the Government of Ontario through the Ontario Book Publishing Tax Credit.

LIBRARY AND ARCHIVES CANADA CATALOGUING IN PUBLICATION

Title: Word problems / Ian Williams.
Names: Williams, Ian, 1979- author.
Description: Poems.
Identifiers: Canadiana (print) 20200295136 | Canadiana (ebook) 20200295934 | ISBN 9781552454145 (softcover) | ISBN 9781770566477 (EPUB) | ISBN 9781770566484 (PDF)
Classification: LCC PS8645.I4448 W67 2020 | DDC C811/.6—dc23

Word Problems is available as an ebook: ISBN 978 1 77056 647 7 (EPUB), ISBN 978 1 77056 648 4 (PDF)

Purchase of the print version of this book entitles you to a free digital copy. To claim your ebook of this title, please email sales@chbooks.com with proof of purchase. (Coach House Books reserves the right to terminate the free digital download offer at any time.)

for my brother
in America

How does it feel to be a problem?
 – W. E. B. Du Bois, *The Souls of Black Folk*

She was territory and words occupied her.
 – Jeanette Winterson, *Art Objects*

*'Nora, it's our stop,' I said. 'Do you want to go home
or keep going?'*
 'Go home and keep going,' she said.
 – David Bezmozgis, *Immigrant City*

TABLE OF CONTENTS

A.

B.

A.

IT IS POSSIBLE TO MOVE ON WITHOUT MOVING FORWARD

suppose you are a black man who is supposed to be white okay you don't have to be a man

suppose you are supposed to be white in other words suppose you are supposed to be a white being

suppose being white in most spaces would be easier than being yourself by spaces here I mean cases

I WILL NEVER LEAVE THEE NOR FORSAKE THEE

whatever in any case I'm taking the little space left me between the headline and the bodylines

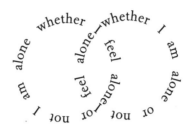

WORD PROBLEMS

let's go on let's return suppose you were say in an airport waiting on a connection on or for

1.

Matthew is not married. He believes he is too mature to use the word *bae, boo,* even *girlfriend,* too young to use *my steady, my main squeeze, my Yoko Ono,* too decent to use *slampiece* to describe the person he is with to the person he is talking to. He associates *partner* with pride, law firms, and neoliberalism. He has been dating the human for only three months but it feels longer. Why isn't Matthew married?

2.

Claire's eleven-year-old daughter is writing a novel. She has not been able to advance it lately because she is having her period. In all the novels Claire has bought or read to her, women don't have periods. Calculate the distance between the moon and the earth.

3.

From the back Ming is often read as a woman because of Ming's hips and gait. Ming's professor for Composition and Rhetoric has been teaching the same course without any change to the syllabus for thirty-two years. He deducted marks from Ming's last paper because Ming's pronouns did not agree with their antecedents. In Ming's final essay, with which pronoun should Ming complete the following sentence: *If someone is born a certain way, then*

4.

John is reading John 1:1 – *In the beginning was the Word, and the Word was with God, and the Word was God* – when the word of God comes unto him, saying, *Call your father.* John's father is schizophrenic and also named John. He was briefly hospitalized when John was born and again when John was born again. Should John upgrade to the latest Galaxy?

there you must be Black I've heard so much about you you're all she talks about enter

5.

Holly is first in the program to welcome members of government. She has forgotten the names of the land on which she is living. As the caregiver of a father with dementia, she recognizes this lapse as satisfying one of the diagnostic questions. She checks. She knows what month it is. She can recall the name of the Prime Minister. She used to live in Vancouver. Now Squamish, Musqueam, and three syllables. Who in the room will behead her online?

6.

Before class, at a faculty meeting, Sam's chair refers to students as *customers*. During class, Sam returns response papers. After class, a point guard approaches, paper in fist, to tell Sam that he deserves a better mark than the B+ he received. He might be a linebacker, not a point guard. His response paper is 500 words and the assignment requires 750. Determine whether Sam is male or female, white or not.

7.

(a)

Sarah's friend texts her: *I'm confused. Did you get my message?* Sarah admits that she has not checked her voicemail in over a month then asks, *Sup?* Her friend does not reply. Sarah checks her messages and learns that her friend's husband has died suddenly. When Sarah leaves a voice message that she's *sorry, unbelievably sorry,* she intends one *sorry* for the husband and the other *sorry* for not checking her voicemail. Graph Sarah's friends and followers against time.

(b)

Sarah's friend has posted the news on Facebook and Twitter. Does Sarah like it? Does she love it?

8.

(a)

Vani is about to end her marriage when her husband says *I love you* for the first time. He is sitting in the egg chair she bought for his home office. How much longer will their marriage last?

(b)

Same situation. That he needs her. How much longer?

9.

N— is a Black woman. N— is not offended by the n-word but is by the f-word and the c-word and will ask her supremacist to watch his language if he drops the alphabet. What do her white boss and Black men call her behind her bbbbback?

10.

In the fitting room, a voice overhead announces, *Attention, shoppers, the store will be closing in five minutes. Please bring your items to the checkout.* Ken is trying on two white shirts. The xs is too noose at the neck but fits well through the chest. The s fits right around the neck but loose in the chest. Is Ken writing this?

MIDAS

Wouldn't it be nice the textbook
said never use *nice* if I came to the end
of a thought or a sentence whichever came
first and the curls of your hair turned
into cryptocurrency. *Burst* would be
a better word than *turned*. Oh, *lorem ipsum
dolor*. Too late.

Sadly the textbook said
never use the word *sad* because see
I forgot this has been happening more
and more I forget what a room was for
I let go of the rope we had to climb
without using our knees.

It is pretty sad
scratch *pretty* that at night I imagine you
imagining me bingeing on delivery
and late-night before crossing the Middle
Passage of my apartment to remove
my contacts. And *sad* again. That I imagine you
thinking of me. But it's my thought. That counts
for never end a sentence with *for* one
should instead say I can no longer remember
for which purpose the room was intended
counts for something, no?

a credit card although they offered everyone else one not yeah! you wanted to be approached

Oh yeah!

Speaking of which

in general I find that you take too long
to respond filler filler to what I'm saying what
are you saying which means I have to keep
speaking of which in general I have to keep
speaking of which do I have enough words
for the word count for something more no
than friends more no more speaking of which
does I have to offer you participation marks
to cut me off?

I'm not asking
for tongue. The textbook says to remove *I*
and *you*. Who's left? *One* is okay. In conclusion.
Whatever ascending interval signals your quiet
desperation is enough rope for me to know you
are still hanging with me in the fifth paragraph
please check in which I restate the thesis.

I buy your... everyone in case you'll I'm gone into an gold up

CORRECTIONS

for Dave Kendricken

I'm sorry. No. A boy a man falls fell falls fell
from a the balcony of his apartment building.
A man I know, used to know, when, years ago, back when
he what was what was something, a colt, a mountain
goat, but human.
 An accident, they she his girlfriend
his ex-girlfriend maybe by now, told me, called to tell me,
texted me. *Sorry to have to tell you this by text.* It happened
like that this morning, that morning. That happened
that morning. About this time. Sorry to have to tell you,

someone, one of his friends, the one you know about
as well as I do, with the name, the clouds for hair and eyes,
the cloud for voice, that friend was there that morning when
the waves were thundering like Arabian stallions when
he rained the sea was sweating in the sun when
a splash quite unnoticed. The ploughman may have heard
the splash, the forsaken cry.

 I ache from loving
this world so much, for loving, I ache sometimes for this
cat's black sweatshirt, for sweat above – the word
gone from me – above – just gone from me – his lip, red eczema
creeping up his neck, tumbling down his arm. Sorry. No. I had it
all, had the his ending all wrong. Philtrum. Un homme, un tom
beau, il tombe, est tombé, tombe, est tombé.

tired or naked or hungry or horny or angry or savage or damaged or just broke assuming you are

 The Beatles. Any time
she heard 'In My Life' she would hum it for the rest
of the day especially, *Though I dada dada dada*
dadaffection. And the guitar lick. The cobblestone
Baroque bridge. The falsetto bit. She would
especially hum all of it.
 The Students' Companion.
as black as hell as close as the grave as dark as death
as dead as a dodo as pale as death as white as a ghost
as sure as hell as black as hell as busy as death
as pretty as a death as gentle as a death
as good as as well as as much as
 In her life
she wrote more letters than emails, read hardcover
letters between lovers, loved the name Abelard
more than Albert, preferred her father dead
than absent. Or preferred to. She raised sons
to walk around dusty countries shirtless, bodies
carved by heroin. And her daughter (which is where
you come in) had many lovers and she loved them all
as much as you. She had many lovers and she loved
your moustache as much as you.

MOOD DISORDER

The true opposite of depression is neither gaiety nor absence of
pain, but vitality – the freedom to experience spontaneous feelings.
 – Alice Miller, The Drama of the Gifted Child

Yes, verbs have moods, not good moods and bad moods though,
[sic] they're not actually moody [...]. The so called mood of the
verb simply expresses the viewpoint of the speaker or writer; their
wishes, intents, or assertions about reality.
 – www.learnenglish.de/grammar/verbmood.html

 You be feeling
wrong because someone wrong did something wrong
to someone wrong wrong, cause the autumn leaves, nah,
your lovah leaves, nah, your father this, nah, your mother that,
nana, Charlie bit, nah, the Internet, nah.
 The therapist
tapsed my thorax for tympani and dullness. She will listened.

I saying I feel nothing. What does that feel like? she axed.
I sayd I said I feel nothing. What does nothing
Nothing feels like water. Good. What kind of water?
Like. Is it sparkling? Like the part of the ocean
where whales mate. Say more, she sayeth. Do you like Ravel?
I sad [sic]. Don't change the subject. I'm not changing
methink. Therefore I been locked behind four bars of Handel
or the Beatles. Nah nah nah nana nah nah.

If the therapist say you should think more
about how you feel I would think she should think more
about what she says and I could say isn't that like seeing more
of what you hear and I might hear her say – because
she hath told me not to tell others what they said
but what I heard them say – I'm overthinking. Too much
I-think-therefore-I-am-ing. Once more. I thought therefore I was
not feeling myself. Once more. With feeling.

 Infinitively
nothing feels like I am *to be* when I would like to be
to feel. With her hands let the therapist say, Imagine
yourself on a raft in the ocean. You don't need to be
Jonah. No one has cast you overboard. If I want to survive
I will would drink have drunken my own sun son. I'd be
worse than Cronus. Let there be Sprite then. Infinitely, I am
the naked blur pushed down a staircase.

 I am only trying to help
you. She is only trying to help you from feeling. Wrong.
From feeling like. Wrong. From feeling like you. Wrong.
From feeling like you should be. Wrong. From feeling like
you should have been. Wrong. Born accidentals
in Chopin's right hand or ragged claws in Beyoncé's
fan-machined manger.

long as you both shall live and so you commit to eating your scone is there a problem here no

I feel you. you feel me? I feel you.
I feeling you. you feeling me? I
feeling you. you feeling me? I feel
like you do. you feel like I feel. I feel like you do
you feel like I feel. I feel like you.
do you feel like I feel? I feel like you. do you
feel like I feel? I feel like you do you feel like
I feel like you do you feel like I feel like you do
you feel like I feel like you do you feel

you feel me no you feel I feeling you I feeling you you feel like I feel like you do you feel like I feel like you do you feel like I feel like you do you feel like I feel like you do you feel like I feel like you do

officer is there a reason why you're sitting here I'm waiting for my flight where you headed

Charlotte what takes you to Charlotte my brother I don't see any other passengers in this

area it's quieter over here this gate is closed is it it is okay join the others okay over there

there there kay kay K K K K KK KK K K K KKKKKKKKKKKKKKKKKKKKKKKKKKKKK

But the object would not say to the subject, *Object
verb subject*. There was no fight. But subject went
to sleep facing the unfinished PAX closet, turned off
turned away, in other words, from the object's objective
case pronoun. The object wanted to explain the construction
object verb subject is a kind of grammatical impossibility.
Also personal. Three-fifths personal. But subject's personal pronoun
or inner child should not take it that way. Some phrases
literally could not be said.

 The syntactical problem
could be traced to the object's possessive pronoun mother,
another noun, whom the object suspects was unable
to verb pronoun as more than an object. Object's maternal friend
said, Another noun verbed pronoun as best as pronoun could
though pronoun wanted to be verbed differently. And that *literally*
and *figuratively* were embattled.

 The object began to repeat
the sentence in question to the reflexive pronoun
in the PAX mirror. As a kind of question. Until wax dripped
from the eyes. As a kind of statement, the subject floated
into the room wearing an heirloom fur coat with red lining
red silk lining I can tell you now that it's over
because you may never otherwise touch the inside.

THE GREAT EXHAUSTION

KK

for Francine

> You are probably sleeping?

> In a debilitating funk
> though things are going
> well. I don't know how
> folks are generally happy.
> How you doing?

> Trucking through with
> great exhaustion. There
> was a reason why I woke
> up thinking of you.

 You are getting sleepy
very sleepy. When you wake you will not remember
any of this. You will awake as if from a routine cleaning
and the hygienist will give you a toothbrush, a tiny floss,
and a mini Sensodyne. Clinically proven to build relief
and daily protection for sensitive– It is not injectable
unfortunately. In Whistler your white friends ski
down their incisors.

 How many episodes before Netflix
jostles your shoulder and asks if you're still watching?
Are you? You don't drink but it's all you do
in the evenings alone while your white friends whistle
down Whistler. There are mountains and molehills
of words for what you are. sad. feel. sad. are. it. Are you

KKKKKKKKKKKKKKKKKKKKKKKKKKKKKKKKKKKKK KKK KKK K K K KK KK K K K K

sleepy yet? Seasonally affected? Affect disordered? Begrudging
all the whistlers who cheerfully eat protein bars after sparta
typo sports? Street view autocorrects East Hastings
to a street of gold. A caterpillar enters its sleeping bag.
You are not a caterpillar. Don't expect wings
to applaud your waking slow. Your life is not life everlasting
or life more abundantly. You are only tired so very tired.

A tree is falling in a forest the tree is falling in a forest
the tree is falling in the forest a tree is falling in the forest
and no one's there. It is falling in slow motion toward you
yes you are there it is falling slowly with its branches
outstretched I said you were there. Toward you.
I said no one's there. You thought you were there.
Slowly falling still. At the sound of my voice you will
turn into daylight.

there there there there there there now now there there come now there there well well

And are you awake
now? Did your line-of-credit increase get approved?
Will you stew beef in the slow cooker? In *The March
of the Penguins*, the male penguins huddle together
all winter with eggs on their feet. In Antarctica.
If there is such a place. The moon landing. Thomas
actually wanted to finger a fresh wound without
medical gloves.

You believe bicycles
will save mankind. You'd find a more gender-sensitive
word for *mankind*. You are kind. Not one of a – one of a
genus maybe but not – kind. I know three evenings
of you. Everything else I had to make up in the night
so they wouldn't steal your body. For instance
or is it for example your parents rolled you from
their flippers then when you hatched your father spit
milk into your tiny beak.

Time for a grand statement
preferably involving ice. I guess it's this. There's a certain sink
with an automatic faucet in the third-floor men's bathroom
which if I were to guess registers me only
ten percent of the time. I keep trying. I suspect
there's no shortage of water behind its stillness.

CART

were skins By the sixth time
we met we. happened very quickly The progression to nekkid.
held the handle of the oven for balance When removing my socks
I. me as you shed clothes near the nightlight in the hallway
You beheld. wouldn't call it stripping I. didn't I. And the evening
and the morning were the sixth day.

during the night
Daylight saving time ended. into end times We fell.
Where were you child when you oughta been prayin'
all on that day? Nina Simone was singing. the bedroom
We couldn't say. ourselves with aprons of fig leaves
We covered. Who told thee that thou wast naked?
And God asked. me the woman You gave. the woman
me. I don't mind that version. Oh look I screwed up.

call it a garden I wouldn't. nothing floral was there. Sorry
that should be, Was nothing floral there? on my socks
Dressage horses leapt and trotted. Another leap.

a lonely life you led · which follows which · a lonely life
you left · for me · me for · which precedes which · a lonely life
you led a little life you lived a little life alone in a hallway
before me you

the person you were does not have important problems more important problems more problems

Instead of wealthy wealthy people
say comfortable quite comfortable they're quite comfortable
to describe themselves and their silvering friends
who are building houses on the island. They may say well off
in lieu of wealthy in lieu of rich to distinguish themselves
in lieu of Reich from the nouveau.

I stack great blocks
of Great Value Cheese in my cart. I can't taste the difference
between fort cheddar and mild cheddar. I know my cheeses
by how orange they are. Fort is oranger than (what rhymes with)
the other.

Instead of a plate and a potato peeler
breakfast at your place involves a cheese platter
and a Dutch cheese slicer. Three wedges of cheese
audition. To vote call 1-866-IDOLS-OI. *Sharp* is an acquired
word for an acquired taste. 'Tis better than saying I like the one
that tastes like my childhood. I'm learning.

A fromagerie
is more specialized than the No Frills cheese counter.
Note: une fromagerie but le fromage. I like pictures of cows
on my cheese. Know where I'm coming from? An island
in the middle of nowhere. *Dwell* hath commanded thee
by name to fill thy condo with uncomfortable Danish furniture.
There are two people at a table for six. Note: not two of us.
One and an other. I am the sharp colour of a grimace.

PICTURES OF COWS

but suppose you are white and you have an important problem you are on the academic job market

The only thing I need to ration
is data. My plan changed. Cheese used to be
scarce on the island. Though cows weren't.
In the days before unlimited milk, cheese,
and data, there was a trade war where calves
were taken from their mothers and sold
as chattel. Don't quote me on that. It happened
before post-truth so it may or may not have.
I remember peeling clingwrap from cheese
so sweaty it must have been running laps
around a savannah. Maybe cows did used to be
scared. Only now do their faces make sense,
the chronic depression as they chewed their gum
and dipped their broad noses to the bottom
of the fence.
Sorry. Can't meet for dinner
tonight. Not so well. Another time?

CLICHÉ

 I was all the clichés of a man in dopamine:
what are you doing now are you thinking of me as well
should I message you? I made myself sick.
There were 48 unread emails and you're the type a)
to keep a minimalist inbox and b) to leave your phone
at home and go biking through the rain. Apparently
one gets little hits of dopamine every time one gets
a ping. So said a YouTube life coach.
He came highly recommended based on my previous
viewing history. Should I buy you a grocery-store
bamboo when will I see you again and after that again
when will I see you was it me or did you
ping when our elbows found each other
on the armrest did you mean to ask me to *The Killing*
of a Sacred Deer or was it a chemtrail? Another. 49.
Let me count the ways. Let me not to the marriage
of true minds admit dot dot dot. Last chance
for Insider Previews before Pre-Construction Sales.
What is your iPad access code? I saw a runner
at an intersection wearing spandex that cut off at the knees
and naturally thought of your needs. For a while
everything pointed youward. The weather
was or was not like it was when you zipped your breaker
to your chin. Like a Vegas croupier, I tried to deal
my thoughts, to get them all out, as they say,
on the table.

It's over. It was nothing and never new.
One might as well start reading here. Just adjust the tense.
O my Luve's like a red, red rose
That's newly sprung in June.
O my Luve's like the melodie,
That's sweetly play'd in tune.

DO YOU KNOW EVERYONE YOU KNOW BY NAME?

you killed the longlist skype interview slayed it and you're presently waiting on your flight

Stuff be happening to me in the future already.
For example? You want an example? For example
no nod from the neighbour who knows me
and knows better than to not return a nod
within thirty days. That you were seen –
that I was seen – that I was not erased under *you*
cannot be proven. Support your answer. No thank you
for making space for a Civic. That happens
to everyone. Cut back on reading so much
about microaggressions. Civics are not known
for their civility. Not the white ones. True. What
I've been feeling I've made up so I could have feelings
to manage for a slight raise. What happened to me
in the future I've imagined so I could have a future.
I believe the children are.

 I had a dream
in which the neighbour was jaywalking across Robson
in front of the Sport Chek in my dream in his bubble
parka jaywalking through my dream with a white
plastic bag over his shoulder. We have seen
each other almost every morning since then
yet he has never shared what he was returning
nor will he ever admit to seeing me
in my dream.

RESOLUTION, A SONNET

to the campus visit you are eating a scone and researching the competition in private mode

Your aunt is in a hospice should you visit yes
you should but aren't you you are out west no
and she is in Toronto. So. Your tax refund yes
is direct deposited and you could aff— but no

that money is for this. Get your eyes checked, an ex
said. You cannot tell whether the last letter is a Y
at the free-eye-exam-if-you-buy-glasses or an X.
Your texts have gone from words to letters, y for why,

c for see of course u thought your phone needed an upgrade :)
Too low res. Your books too. You message your cousin :(
(your ex too) to express your sympathy. Emojily. :)
she messages back which puzzles your flesh face (:(

she must have meant) (which is better) (you should maybe
call to clarify) (one or two) (search contacts) (B)

without qualification you are qualified you declined a preapproved credit card offer earlier

The Boomers go *boomkaboomkaboom, boomkaboomkaboom*,
go from line 9 to 5 while you shadow them with a scythe,
teach sessional, practice a marriage like foul shots, read up
on autism, read Canada Reads, take a postable vacation
in Valencia or Icarus filter that leadeth to destruction. 5
Or you echoed them: you u sat at their heir chairs airs
and clucked at Apple stock, bought a house in a market
on one of Saturn's moons, streamed *Moonlight*. La la.
Composted. Posted. Recycled. Cycled. To destruction

 10

that is, this message will self-destruct in four lines. What
will happen to your profile, in three, in the afterlife
assuming of course you have one? In two. That is, after
cancer swells music through you, Oh my love, my darling
I've hungered for your touch that leadeth to destruction. 15

but you entertain the possibility that a person of colour might get the job only because she is

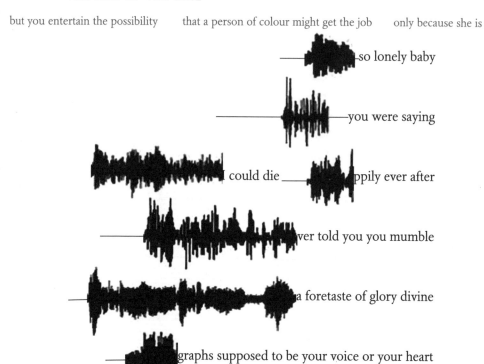

so lonely baby

you were saying

could die ppily ever after

ver told you you mumble

a foretaste of glory divine

graphs supposed to be your voice or your heart

is my song

AND LO I AM WITH YOU ALWAYS EVEN UNTO THE END OF THE WORLD

a person of colour not to throw shade when lo security spots you sees you and the same thing

will end well. I'm sure it will end but for you, I'm not sure it

that happened to the black man you happened to be previously happened to you just suppose

well would the same thing happen to you please in the space below calculate the probability

beyond probably or possibly show your work

B.

IT IS POSSIBLE TO GO BACK WITHOUT GOING AWAY

let's say you're the type to replay events

to hit repeat on songs while running

around or from or away

to reread books

HAIR IS CHOKING THE DRAIN

Someone should clean it
the drain in the tub and the drain in the sink
with a hairpin or a paperclip or a finger. Not it.
Clean them.

My friend
in Africa has a cleaning lady. They are both Black.
He tidies up a little before she arrives. Not too
much. Not to repeat myself. They are both Black.
Just a little. Because. Shall I go on?
And he doesn't make her doesn't ask her to
fold his laundry because his underwear
something about touching his. He told me
(but I forget) that he came home one afternoon
and found her taking a shower in his it goes
without saying yet in his bathroom. There's no
hot water where she lives. And she's been drinking
his bottled water. There's that.

So anyway so now
there are plot developing tensions between them
that can't be addressed because she's you
know and some of the hair in the drain could be hers.

WHERE ARE YOU REALLY FROM

1.

In the guessing game the white man gets many guesses. He may continue to guess even after the answer is revealed. Could you be loved, he is guessing, and be loved? If I answer correctly he wins. Say something. He is team captain and sole player and horse and foxhound and whistle and first-person shooter to my birth. Say something. It's not a trivial pursuit.

2.

While a white man waits for me to answer he is searching his inner Wikipedia for a fact or a current event about the island or continent I am. Carnival, genocide, pirates, cruise lines, a woman he used to work with, blood diamonds on the soles of her shoes, a-wa a-wa. The list could be longer. He knows a lot about where I am from whether I am from there or not.

in the airport

by two white women in blazers

then you were a

few bites

into an overpriced scone

when airport security

3.

I played tennis with a white man who would play my shots when they landed beyond the baseline and my faults as well, as proof. There's a long wake across the Atlantic. Proof of. *I don't know anybody who's actually still racist. I don't know why we're even talking about it.* Because of you, I wanted to say while waiting to receive. *I'm totally team postracial.* He meant nothing by that which is not to say he meant well.

4.

Post that, at a church potluck I intervened for a friend: *He's not going to tell you that, man.* And the white man looked at me as if I were his phone and had lost reception. He explained a genocide to a Filipino woman. And my friend with the French name from an African country, who was born post conflict and had never been a child soldier, said, *Next time I'll just say my name is George, George, George of the jungle. The Congo is so close anyway.*

WHERE ARE YOU

from where are you
no really where are you from
no where are you reallynot of
no from where no from
where now

know you brought me here they are no where of the world even as I am not of the world no where no where no where no

TU ME MANQUES

is how the French miss.
Backward. Like car wheels in commercials.
You me miss. Word every possible the place wrong
in. There are only three.
 I had a
farm in Africa, no just a friend on the French-Swiss
border who argued the English *I miss you*
didn't make any sense. Had? How could you
meaning me miss me meaning him. Easy.
You he explained miss me because we are not together.
Who's missing? I wanted to know. You are. You are
gone somewhere from me. *La lune.* I cannot be missing
from myself. Ever. You are missing from me and here
he clamped a love handle and that causes me great
how do you say *l'angoisse.*
 We are apart now
we never met actually we Skyped through the cheesy
maze of our friendship. He made a joke once
when I asked for details (he had a postdoc
on breast cancer proteins) that he was in charge
of terminating the rats. By guillotine. That was the joke.
Then he quickly explained the real way – an injection
I think. How faint the tune. I could never tell
how tall he was or ask correctly in French how high
the moon.
 As long as we're longing I had a
farm in Africa, no just another friend on the border
of Rwanda and the Congo who said *I miss you*

for *tu me manques* was a perfect and incorrect
translation. Just trust me. Everything makes sense
until you have to explain it. Have? You don't say
tu m'aimes for *I love you*. Correct. That is very true
but *surtout* because I don't love you. See the stars
comment elles brillent for you. Wait, wait, wait. Not you,
not your words, not your feeling.

where do you think you're going

where you heading

where you headed

Charlotte

what's in Charlotte

who actually

WHY DOES EVERYTHING HAVE TO BE ABOUT RACE WITH YOU PEOPLE?

 Leave yourself
behind for a minute in this poem

you are reading a poem and (I, too, dislike

poems like this) in that poem a man has left

a note you have read that poem

before you were supposed to be shocked

by its audacity but you were nineteen

and more strike struck stricken by the cost

of the anthology than by that poem (stop

saying poem)

 now you are say sixty (sixty)

and as you're downsizing you come across

the anthology with that poem is called this

is just to say (sixty) as I'm sure you've figured

out by now and you are the type who cares

more about the price of plums than plums

so do you keep the anthology or not (don't

answer yet)

you want to know what you wanted

to know at nineteen why couldn't someone tell you

straight up whether this poem is about more

than plums or is it just to say this is to say

at sixty you have lost your hair to grey

and menopause that was irrelevant forgive me

you are so sweet and so old

why should you

decide you will not forgive him for the note

or the poem it's hard to parse who you are

from who you ought to be to parse your creole

from the queen hard isn't it to recognize yourself

in that poem although he says *you* to the woman

in that poem in this poem you know he does not mean you

of course cannot even see you of course every poem (stop)

every poem (stop) everything you have ever read

has been addressed to someone beside you (stop)

there you go there you people go again

making everything about ~~yourself~~ yourselves

or should it be you

really really sit there sit where over there over where there there kay kay there there K K etc. etc. not to get fresh

AND FINISHED KNOWING — THEN —

I said we'd talk later – I wanted to
dance with somebody – to feel the *heat* –
I turned off the burner – The microwave
beeped – Don't you want a chance
say you wanna dance don't you want a chance –
I said, We'll talk later –

 then my inbox filled
with ears underwater. then I noticed all the shoes
at my door were mine. then the slats of the bed
came loose and I plunged into teeth. then all
the onions turned black. then a loved one
unloved me online. with somebody who – me.
then the neighbour's unhooked landline
stitched through the wall –

OUR EYES MEET ACROSS YET ANOTHER ROOM

white	white	white	white	white	white
white	i	white	white	white	white
white	white	white	white	white	white
white	white	white	white	white	white
white	white	white	white	white	white
white	white	white	white	white	i

direct deposit you

in their midst

for safekeeping

so you can desegregate from yourself

suddenly

wait

suddenly

THE PAST SOMETIMES APPEARS CONDITIONAL

The cause is the consequence.
> – Frantz Fanon, *The Wretched of the Earth*

1.

He would get pulled over
whenever he tried to download *Blonde*. He would be
searched for F-bombs but not for H– E–
double-hockeysticks. He would get chokeheld
for wearing a hat in the hallway. He would
be tasered for balling his Whopper wrapper
and dropping it on the floor of the streetcar.
He would get shot in the back every time
he incorrectly used MLA format in his essay
on *A Midsummer Night's Dream*.

2.

He would take
some E if he didn't have to preach
austerity. He would hire a tennis coach
if the consultants he hired would actually
fire the people to be fired. He would upgrade
to the latest Model X if millennials didn't
default on their student loans when he raised
interest rates. He would get his shoes polished
at the airport if the kiosk weren't so far
from the platinum members' lounge. He would
be placed on paid leave if he raped the trainee
from Dawson. Sexually assaulted. Allegedly.

a herd of antelope pronk through the terminal what are they doing here it's okay they will pass which reminds me suppose

— 62 —

INTERSECTIONS

The struggle over which differences matter and which do not is neither an abstract nor an insignificant debate among women.

– Kimberlé Crenshaw

with Audre Lorde

we have *all* been programmed

there is neither Jew nor Greek

to respond

to the human differences between us

there is neither bond nor free

with fear and loathing

there is neither female nor female neither is there

for floating

but that was okay

because you could be good

at track

and by a chemistry teacher

that you couldn't jump

ignore it
and if that is not possible

copy it
if we think it is dominant

or destroy it
if we think it is subordinate

he she
thought thot
she she dog doggess dog bitch
was could be stud studette stud bitch
a very every sire desire sire bitch
human woman stag staggettesse stage bitch

actor actor

— 64 —

thou shalt love

but we have no patterns

thy neighbour

for relating

as thy neighbour

across our human differences

loves her selfie

as equals

to a solution

no matter how obvious it might be to you

but had to show your work to prove

that you weren't *copying*

and were

and confusion

in the service of separation

misnamed and misused

as a result

do unto others as you would unto a white woman

those differences have been

also asked the meaning

of antagonism

in front of your middle school classmates to prove that you had in fact written

CONSOLATIONS
for C. G.

Consolation No. 1

 Your name has been changed to Liszt
to protect your identity. You have your own life to pluck
brown leaves from, let alone this clot in your rhizome.
Apparently, by state law, the abortionist has to tell you
about the heartbeat and show you a picture. I imagine
there are pamphlets in acrylic holders along a wall. The doctor
calls the pamphlets literature. Meanwhile the lit magazine staff
sequences acceptances. Meanwhile Mengele selects twins
behind the yellow line of the platform. Someone is responsible
for shaving hair. Meanwhile in an upstairs apartment
a teenager practises the left hand of a consolation.

Consolation No. 2

*I won't ask you if you called
the doctor I found you,* Liszt's partner says. He waits
for Liszt to answer. You are driving along a lake
of amniotic fluid.

Liszt hasn't called. The baby
is inside of you, sleeping in benzoate. He she they it
is is was is sucking his her their its thumb
on a Grecian Urn. The French Open begins
next week is over. The lower ranked players are playing
qualies already over. When you turn the conversation
to dust, your partner asks, *So does the loser get
eliminated right away?* And Liszt answers,
It's sudden death, yes.

Consolation No. 3

How could you | be both yourself
and this other | being Liszt?

At some point | one becomes
human and not | one's mother.

At what cell division | did you will you
become a mother | and not human?

who was wearing a backpack

and she said

don't steal my wallet

it was a joke

understand

you laughed with everyone else

Consolation No. 4

If it's any consolation
I lost my tennis match. I was playing on the courts
at Kitsilano Beach with a doctor who was out of work.
He slaughtered me to love.
In the adjoining park
mothers parked Hummer strollers and did yoga
with their babies. An infanta wandered to the chain fence
and applauded every time I shot the ball into the net.
If that's any consolation.

Consolation No. 5

Rename Consolation No. One.
Save as.

assuming you are the black man

you are are supposed to be

you have a history but not a past

in other words

you have a past

Consolation No. 6

Your unreal name is Gwendolyn Liszt
in case you forgot. You take the first name
of your mother and the last of your father.
Your cells can be sorted on Excel. Do you
remember the children you got that you did
not get? It's from a poem you vivisected
in an essay.
 The future statements
are all true. Liszt has a tiny waist. In university
you were sick with something mysterious
then learned the illness in your body
had a name and would not go away. Liszt
does not expect light at the end of the Fallopian
tube. ∴ You will not get better. ∴ Liszt will die
of complications from her mother's genes. You will
go back and forth between being and nonbeing
yourself and her. The name Liszt protects you
from your identity. Now no one will know
whose baby fell down a well you will know.

CONVALESCENCE
for P. C.

 Gonna ask a few questions
to verify your identity if that's all right with you. How many
seizures did you have over the last twelve days? Diabetes
in the family? Diabeetus? Sugar? Glucose fructose? Honey
you sure?

 Would it have been easier to have loved and lost
or to never have loved been loved at all when you were
entering renal failure? Can you trace the etymology
of renal? I'm looking for one word. It falls from the sky.
Not manna. Rhymes with sane. Try. Not pain. Miss Otis regrets
she can't do lunch what did you have access to your account
without that information.

 Do you feel well enough to continue
as yourself or do you still feel like a concept? Did a firefighter
place a wooden hanger between your teeth to prevent you
from chewing through your tongue? It was a wire hanger?
No guff. I'll update your records. Any aspartame in the family?
Trans fats? Any Sweet'N Low talkers? I know I asked
you that. What isn't redacted from your memory by Russians
apart from your dog? The name of your first pet. Which died.
Is it it or is it he? Who died?

purchase

near your laptop

or barbecue in the park

or nap in university common areas

or sell bottled water

or listen

ON THE USE OF YOU

 Am I using you
incorrectly? Unstressed stressed. Have I been
I mean using you to mean me? You have.
I think you think I'm you. Thank you. I am
flattered. I've read my Whitman. Contain
multitudes and all that jazz. Real cool.
Not always. Contrary to what you think, what I think
you think, correction, I am sometimes just objection
myself sustained. As in all this right here.
All dis, baby. Not always. The *Times* regrets
the error. Times regret.

 I'm home
about eight. You're shooting pool at Vanity Fair
for the geometrics. The Eurythmics. Just me
and my radio. Some of them want to misuse you.
Some of them want to be excused.

 Ever wanted
to throw yourself into a into a volcano no no
on the mercy of the court? Cry out in your best
Blanche drawl, *Your Honour in my defence I am
but a simple pilgrim.* I'm being – I've been confusing
us all our life. You meant *lives* just now. No, I think
I meant *life.* Progress, Pilgrim. Now do I see myself
in an error. Did not the shepherds bid us beware
of the flatterers? I'm losing you aren't I losing
you aren't I aren't I aren't

 I don't mean the following
Marxly or Maoly, only grammatically, okay?

Argumentative, Your Honour. People are not persons
or individuals. Hearsay, my honour. In that case,
I mean, there is no such thing as persons.

supposing you are

in out-of-fashion postmodern fashion

the sum of the above experiences

prove that the present one

the one

PEOPLE FORGET THAT

other people are people
when they get whacked in the groin
in meme GIFs. People are funny like that,
how easily they let other people slip
into piñatas or sex machines.
Remember people
are still people when they're so famous
you never got the chance to see them live,
schlepping their ex-selves from bar to bar,
choking the neck of a beer and singing the same cover
year after year, Sundown, you better take

And why not give people what they want,
the platinum laugh, the karat skull? Forget that

people forget that you're people. It may be too late
to be someone.

AFTER AUTUMN

with resurrections of P. K. Page

What should we be then

Nothing to do.

for this year's office party

Ourselves maybe

So much to do. Too much to undo.

tell yourself you are something

And wander on the boulevards, up and down.

Nothing to really do or drive

but to drink black
and click clips cats

Kettle boils dry

little Mondrians through the town

God's face is always there

Should we end the year as a colour

Whoever is alone will stay alone

as a stain trailing a pick-up in Jasper
like Just Married cans. It's been happening

so long.

忙 BUSY

Note: The character for busy *in Chinese consists of two parts:* heart *and* perish.

As my ex was leaving me for Chicago I had to keep
my heart perishing in my mind. Knowing her,
even in airplane mode she would find a way to perish
her heart herself. Who needs a man? She would find herself
drowning in the in-flight entertainment or floating
on an inflatable uellow life raft. *Yellow,* I mean.
The *u* is so close to the *y*. The *i* to the *u*, the *s* to the *x*,
the CTRL to the *End.*

 Don't you worry
about our hearts. Our artichokes are canned in citric acid
and laughter. Plus we do a lot of cardio. She calls me her ex
although we are back together

 at least as of this late
capitalist moment. Academics like to prophesy decline.
She is not an optimist yet her flight was on time,
unfortunately. I began dressing other people's faces
in her face, the face she wore at the edge of security.
We could not go on together. I could go no farther
than where the US government had placed cherubim
and a flaming sword. Beyond us all the hearts in the airport
perishingly removed their boots it seemed. I aimed a kiss
at her prefrontal cortex, real cool, but in my limbic system
my arm was flailing among fins and waves, sharp
rows of paper triangles stacked behind each other
for a puppet play. On my calendar I planned to line up
the deadline days against a brick wall and shoot them
execution style.

Someone separated a heart from a body
and buried it interred it entered it in a church in Toronto.
True story. The heart belonged to Elmsley. Body too, I guess.
He was Protestant. He had a change of heart – I couldn't
resist – and converted to Catholicism. A sprinkler emerges
and spritzes the heart every hour like lettuce in the produce
section, only with blood instead of water. How else does one keep
a separated heart from decomposing?

as here and now back to you I suppose the question now there are many that you ask yourself is what is it about you

累TIRED

Note: The character for tired *in Chinese consists of two parts:* field *and* sew.

A man in a field crushes a woman as she sews as rock
crushes scissors in Rock, Paper, Scissors. He is the numerator
and she the denominator. I am da terminator. It's not radical
feminism or Marxist theory. According to the radicals
the workers are absent. Only work remains: field/sewing.
Maybe we're not tired of work, maybe we're only tired
of each other.

 In the field I would have been
harvesting cane to make sugar, elsewhere cane would have been
cotton, tobacco, tea leaves, rice, cocoa and she would have been
eyeing me from the porch and sewing the children's
mouths shut with black thread. Have you seen that album
cover of Madonna? I suppose she had good reason to quit
her job. Not Madonna. Keep up. The black thread
of unread messages. *Now! Now! Now!* Now NotMadonna
spends her days 🕐 buying radish from a farmer's market
and messaging me. ✓✓
 I finished reading *My Year of Rest
and Relaxation*, best cover that year, and promptly fell asleep
while elsewhere my ex climbed a mountain with her index fingers.
I elaborate but I do not exaggerate. By tired I never meant I needed
Ativan, sheep jumping over a fence, *Hush little baby*. I meant that
I existed in a state of grunge feedback or white credits rolling against
a black back–

Don't say a word. Whenever I see interracial couples
in the mall trilling through hangers for the right size or admiring
their mirror selves outside dressing rooms I think the same thing.
Doesn't everyone? What is one supposed to think? That's what I think
for the purpose of public disclosure. I'm such a wimp. Buy me
a diamond ring. The men who send dick pics to women
with graduate degrees get a lot of air but most of us
don't. An Instagram ad targeted me: *When I think of Beethoven*
I think of defiance. If he were alive I could see him
with a Black girl. I could see him making a crossover album
with Drake or Aretha

 if she were alive. In any case
after my heart perishes I sit in a field of needles. In Bollywood
a woman sews a button on a man's shirt. In Hollywood the scene
was deleted and no one missed it, to great critical acclaim. I didn't.
You neither? You too?

CUANDO PIERDO

 Yo are learning Spanish
from an app. Yo speak into the phone
which doesn't always recognize yo
so yo shout at it, like an American tourist.
I ask, *What's a* camisa? because I watch a lot
of action, seasons of action, and it sounds
like a moving truck of furniture careening
into a crowd then off a bridge into the sea
then under into into over. Cut.

Action. The app tells yo yo are correct.
Ella consigue pan – She is consigned
to pain or she gets bread. *Conseguir* is a new
verb for yo. *El niño* – the hurricane – the child.
Yo sounds like *Jo.* Tap the pieces. Yo are
correct. On the couch where I many an evening
lie drowning in new seasons yo tap and shout
and without knowing it rescue me
from the truck that went off the bridge.
I got lost. I am lost. *Diez* is not God,
it's just ten. *El niño* is child or boy. For real yo,
Spanish is like a whole other lang.

 Identify yourself
immediately. Neighbours will notify the authorities
that someone is learning Spanish on my couch.
The furniture can't be recovered. Nor the bodies.
It may appear in yo terror as if yo are backing away

slowly with arms up but yo are only going
to the balcony for air. For organic air. The building
is surrounded.
 In the last scene the star jumps
from a helicopter into the sea.

CUANDO ME PIERDO

 I wasn't watching I was
reading I had lost myself looking. In rhapsody
pron. rapcity reading Lorca to yo. When I looked up
yo were alphabetizing books from an orange
leather chair, not really
 paying attention to me,
to Lorca, to me. Typical. So predictable even
Google could autocomplete our future. Amazon
would recommend we try. We have two versions
of. In one Spanish included. In the other
Spanish sold separately. One costs more than the other
because it costs money to build a wall along the spine.

Previously on *Lost*, after writing each other for weeks
yo asked for a photo so I sent yo one and yo wrote back
Sorry, I don't think we're a match. But yo did not block me.

SOMEONE LIKE YOU

The safety fence at my condo site was plastered
with concert posters then frilled with graffiti.
It's been seven hours and fifteen days for the hole to look
archaeological. Yellow excavators clawed at the land
and trucks hauled away the earth. My heart
being my heart assumed that the dirt
would become a hill for underprivileged children
to sled down which children would sled. Awk.
Maybe it has.
 I belonged there. At the last of three
funerals that summer, I grieved closing costs
when I should have been inging, singing, *Oh what peace*
we often forfeit. Oh what needless pain – My plot
of forty acres and a mule works out to 600 square feet
when adjusted for inflation.

 Whatever I mean
by *my heart* is now being monitored by security
as it descends the elevator shaft to canto 5
of the inferno because of what happened
after the Met Gala. The thing formerly known
as my heart drives a little red Corvette. It parks
among minivans.
 The heart is neither lit
nor fig. Online I saw a photo of y'all kissing
atop a mountain, toqued and gortexed-out,
looking at the cam with eyes half shut. Awk.
You hiked up the rough side of the mountain

without a mule. My ♥ logged a drum track.
I suppose I will post I'm happy for you I wish
nothing but the best for you two too
but here, for the record, mine, I am writing that
I am not happy I am not happy for you I do not wish
you anything but I do not wish nothing
but the best for you.

TELL ME WHEN WILL YOU BE FINE

He was of sound mind
when he renamed himself Englebert Humperdinck.
Of all possible names for spitting images is it possible
to number one's imaginary? Children go where
I send you. Children comma go. Two comma Three
comma Five comma Seven. Consecutively number them
optimusly prime. Three point one four one five nine
is a child of infinite conception to five places. I rename
myself a fraction that sires a decimal that Jack built
that recurs forever, that recedes forever. My child
the repeater and I are not the same. My imaginary
and I are facing viral mirrors.
 Born Arnold George Dorsey.
Born Malcolm Little. Born Persia. Born Brad's Drink.
Born an unmarried woman.

Honeychild, by the last scene
of *Call Me By Your Name* when Privileggerio
is looking into the fire and crying I am out
of licorice and more pissed than I have vocabulary for.
Spoiler alert behind. The purpose of this paper is to.
This is a node anode an ode that will rile you
comme| comments| commensurately. How can I
make your stay here 👎? Help me help you
Stop resisting. Help *me*. Help *you*. Third time's the
QUANDO QUANDO QUANDO

Is *quando* with a *q*
Italian, Spanish, or Portuguese? Where is it from?
No, before the dancing tuxedo, where is it really from?
Outside the theatre, a man in a Statue of Liberty costume
spins a large arrow. He's listening to Janelle Monáe
while we thank God, I thank thee, that I am not
as other men are, extortioners, unjust, adulterers,
or even as this publican. Nobody knows the trouble
he's seen listening to. He could be twerking to
Italian opera. *Vincerò! Vincerò! Vincerò!* That's straight
from YouTube via Google via Firefox via my Android
device. Do you accept cookies? A star is collapsing
on TMZ.

But not an ode to the film. An ode
to the media coverage of a black man, which one,
who gets shot, which one, more than three times
which, for carrying his phone. Trigger warning
in retrospect. He gets shot eternally on CNN
while Privileggerio flickers in front of a fire
and servants set the table behind him. *Sir*
step away from the vehicle.

TRÄUMEREI

Norman drops part of his Hostess cupcake on the floor. He doesn't want to get in trouble. If he picks it up and places it on his plate he will have to eat it. If he picks it up and places it on the placemat he will have to explain that he dropped it on the floor. He still wants to eat it. Yet he should not eat food that has fallen on the floor. Will the surveillance video be enough to convict the officer who shot his father?

POST-TRAUMATIC

> *… unless to feel something toward someone is in fact to do something to that person.*
>
> — Lydia Davis, 'Ethics'

At Liberty Café, a white mother is playing I Spy with her white son. The son says, *I spy with my little eye something black.* The mother makes a game of considering. There is a Black man sitting in their field. The mother looks out the window and says, *Car, wire, bicycle, road,* and somewhat desperately, *awning.* The child says no to each guess. She turns inside and labels things: *coat, picture frame, mug, shoelace.* The child says no. Can someone be something?

NOTES AND ACKNOWLEDGEMENTS

PREVIOUS PUBLICATIONS

50+ Poems for Gordon Lightfoot: 'People forget that'; *Arc*: 'Word problems'; *Best Canadian Poetry*: 'Cart' and 'Tu me manques'; *The Capilano Review*: 'Where are you,' 'Where are you really from,' 'Why does everything have to be about race with you people,' 'And Finished knowing – then,' 'Tu me manques,' and 'Our eyes meet across yet another room'; *Fiddlehead*: '忙 Busy' and '累 Tired'; *Maclean's Magazine*: 'And lo I am with you always even unto the end of the world'; *Poetry*: 'The past sometimes appears conditional' and 'I will never leave thee nor forsake thee'; *Poetry is Dead*: 'Quando quando quando' and 'Cuando pierdo'; *The Puritan*: 'The Great Exhaustion,' 'Iceberg,' 'Cliché,' 'Do you know everyone you know by name,' and 'The end of the line'; *The Rusty Toque*: 'Gruyère' and 'Cart'; *Translating Horses Anthology* and *The Next Wave: An Anthology of 21st Century Canadian Poetry*: 'Corrections'; *The Walrus*: 'Hair is choking the drain.'

REFERENCES

Here is an index to some allusions.

p. 24, 'Corrections': W. H. Auden 'Musée des Beaux Arts'; Patti Smith 'Horses'

p. 39, 'Cliché': Robert Burns, 'A Red, Red Rose'

p. 43, 'Broad is the way': Righteous Brothers, 'Unchained Melody'

p. 44, 'The end of the line': the voiceprints are made from Elvis Presley's voice and mine.

p. 60, 'And Finished knowing – then –': the title comes from Emily Dickinson 280 [340].

p. 67–72, the six 'Consolations' reference Franz Liszt's six-part *Consolations* (S.172) and Gwendolyn Brooks's 'the mother.'

p. 74, 'On the use of you': Walt Whitman; Gwendolyn Brooks, 'We Real Cool'; John Bunyan, *The Pilgrim's Progress*.

p. 76, 'People forget that': Gordon Lightfoot, 'Sundown'; diamond skull references Damien Hirst's 'For the Love of God;' GIF stills were adapted from GIPHY.

p. 77, 'After Autumn': All of the vertical text is from P. K. Page's 'Autumn' which uses some text from Rainer Maria Rilke's 'Autumn Day.' The poem resurrects James Byrd Jr. at the end.

p. 88, 'Quando, Quando, Quando' references the Stephon Clark shooting.

EPIGRAPHS

To the collection: W. E. B. Du Bois, *The Souls of Black Folk* (New York: Signet, 1995, 43). Jeanette Winterson, *Art Objects* (London: Jonathan Cape, 1995, 75). David Bezmozgis, *Immigrant City* (Toronto: Harper-Collins, 2019, 16).

To 'Mood disorder': Alice Miller, *The Drama of the Gifted Child* (New York: HarperCollins, 1997, 60).

To 'The Great Exhaustion': Texts between a friend, Francine Tulloch-Harvey, and me.

To 'The past sometimes appears conditional': Frantz Fanon, *The Wretched of the Earth* (New York: Grove, 1963, 40). The full quotation is, 'The cause is the consequence; you are rich because you are white, you are white because you are rich.'

To 'Intersections': Kimberlé Crenshaw, 'Mapping the Margins'; all of the vertical text is from Audre Lorde, 'Age, Race, Class and Sex: Women Redefining Difference.'

To 'Träumerei': Robert Schumann's piece of the same name, *Kinderszenen*, Op. 15, 1838.

To 'Post-traumatic': Lydia Davis, 'Ethics,' *Collected Stories* (New York: Picador, 2009, 289).

THANK YOU

Courtney Gustafson, Patrick Cuff, Sheryda Warrener, Malabika Pramanik, Jane Munro, Jim Johnstone, Phanuel Antwi, Jean Claude Kwizera, Moon Kwon, Aaron Rabinowitz, Emily Pohl-Weary, Tariq Hussain, Doretta Lau, Rhea Tregebov, Suzanne Andrew, Kevin Chong, Paolo Pietropaulo. ♥ Chiayi Tsui.

Thank you to Matthew Tierney for editing *Word Problems* with characteristic thoroughness, precision, and indefatigable attention. Thank you to Coach House: to James Lindsay for keeping books alive during a pandemic, to Crystal Sikma for meeting the various design challenges, and especially to Alana Wilcox for bringing this book – and so many others over Coach House's history – into the world.

ABOUT THE AUTHOR

Ian Williams is the author of five books. His novel, *Reproduction*, won the Scotiabank Giller Prize. His last poetry collection, *Personals*, was shortlisted for the Griffin Poetry Prize and the Robert Kroetsch Poetry Book Award. *Not Anyone's Anything* won the Danuta Gleed Literary Award for the best first collection of short fiction in Canada. *You Know Who You Are* was a finalist for the ReLit Poetry Award. He's online at www.ianwilliams.ca and @ianwillwrite.

Typeset in Parisine, Ashbury, Benton Sans, Aragon, Marydale, and DIN Next Pro.

Printed at the Coach House on bpNichol Lane in Toronto, Ontario, on Zephyr
Antique Laid paper, which was manufactured, acid-free, in Saint-Jérôme, Quebec,
from second-growth forests. This book was printed with vegetable-based ink on
a 1973 Heidelberg KORD offset litho press. Its pages were folded on a Baumfolder,
gathered by hand, bound on a Sulby Auto-Minabinda, and trimmed on a Polar
single-knife cutter.

Edited for the press by Matthew Tierney
Copyedited by Alana Wilcox
Designed by Crystal Sikma
Cover design by Natalie Olsen
Author photo by Justin Morris

Coach House Books
80 bpNichol Lane
Toronto ON M5S 3J4
Canada

416 979 2217
800 367 6360

mail@chbooks.com
www.chbooks.com